Sketching for beginners

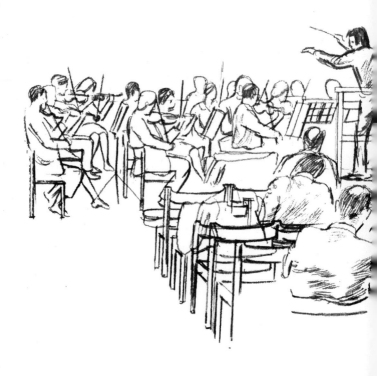

Fig 1 8in.×17in. (20cm.×43cm.)

Sketching
for beginners

Geoffrey Elliott

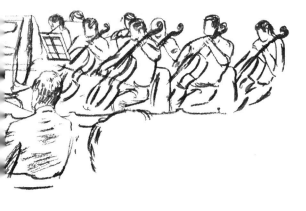

Studio Vista London
Watson-Guptill Publications New York

Acknowledgements
Fig 47 is reproduced by permission of Shell-Mex and B.P. Ltd, and figs
5, 6, 7, 10, 15, 24, 33, 43, 62, 63 and 77 by permission of *Canvas* (Richard
Gainsborough Publications).

General editors Janey O'Riordan and Brenda Herbert
© Geoffrey Elliott 1970
Published in London by Studio Vista Limited
Blue Star House, Highgate Hill, London N19
and in New York by Watson-Guptill Publications
165 West 46th Street, New York 10036
Watson-Guptill ISBN 0-8230-6895-1
Library of Congress Catalog Card Number 77–119489
Set in 9/9½pt Univers
Printed and bound in Great Britain by
Bookprint Limited, Crawley, Sussex
U.K. SBN 289.79796.9

Contents

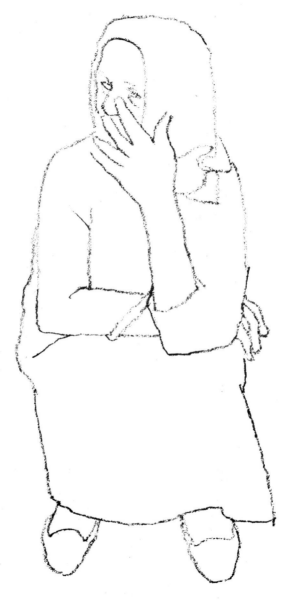

Fig 2 Old woman. 6in. × 9¼in. (15cm. × 24cm.)

Introduction

Why learn to sketch? There are a lot of reasons, but I think the best one is that it can give you so much pleasure. To the person who says 'I can't draw' or 'I'm sure I haven't any talent' the answer is 'All the better because it's much easier to learn right from the beginning'.

Sketching will teach you how to look at things in a special way and you will find that you are seeing the most commonplace things freshly as if you had never really looked at them before, which is very exciting and rewarding. Sketching will teach you how to draw, how to use all sorts of different media, in line, tone and colour, and give you an interest that you can pursue at almost any time and wherever you are.

Sketching need not be a solitary occupation. The image of the artist having to cut himself off from society and go trailing across soggy fields to sit in the freezing cold for hours, while his family and friends agree that he is quite mad, is a false one. On the contrary you will probably find that your family and friends will become so interested in what you are doing that they will want to try it too.

This book will suggest to you how to go about starting to sketch, the ways you can work, the equipment you will need, how to select subjects and then how to sketch them.

Fig 3 Three donkeys. 6in. × 9¼in. (15cm. × 24cm.)

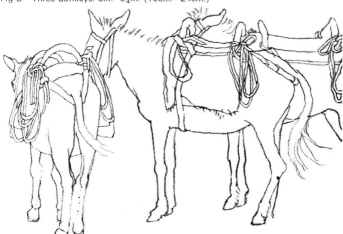

1 Sketching defined

Sketching is putting down on paper in any medium something that you see and want to record. Unlike the camera, it enables you to select and emphasize and omit and add at will until your sketch, whether a brief note or a detailed study, big or small, will have become a personal statement of how you felt about the subject you have drawn and the special qualities it had that made you want to draw it.

Whether you are just beginning or are an experienced artist, and whether you are interested in drawing, painting, sculpture, carving, pottery, architecture or whatever, sketching will be an essential and integral part of all you do, as well as something that can be an end in itself.

You can sketch for many reasons and various uses, and the type of sketch you do will be influenced by its purpose; so for easy definition I shall divide sketching into four main types, the reference sketch, the study sketch, the practice sketch and the statement sketch.

The reference sketch

This type of sketch might be described as supplying material for your own personal dictionary. Something takes your eye and you record it in your sketch-book or on anything you have available.

Fig 4 Reference sketch: fishermen mending nets. 4¾in.×9in. (12cm.×23cm.)

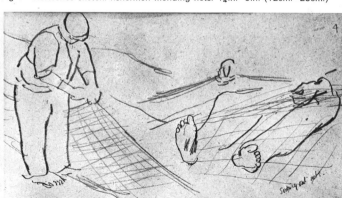

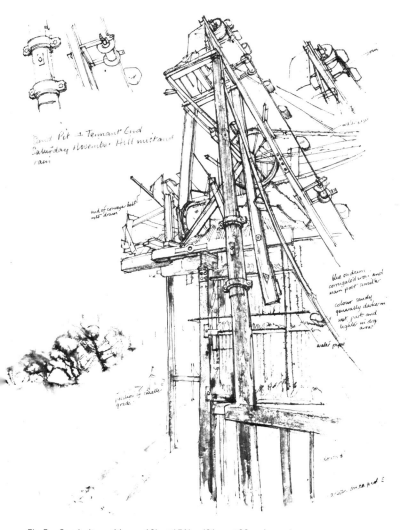

Fig 5 Sand pit machinery. 12in.×15½in. (31cm.×39cm.)

It may be a rock, a group of trees, a figure working or asleep or a group of figures, the position of a hand, a fold of drapery, a piece of machinery which has parts that intrigue or puzzle you, an unusual cloud formation; literally anything at all that makes you feel so interested that you just must get it down or you may forget it.

The sketch may be just a few simple lines, as in the sketch of the fisherman mending his nets (fig. 4), or areas of tone, just sufficient to remind you of the subject and your reaction to it, as a few bars of music instantly summon up a whole tune in your memory. Alternatively it may be a very detailed study of something that intrigues you, as the pen and wash sketch of sand pit machinery on the previous page, or general studies from different angles. You may want to use written notes with your drawing that will tell you things like colour, the time of day, weather etc. All these will provide a dictionary to be referred to at any time, and on seeing the sketch you will remember that ephemeral moment, maybe years before, and be able to recapture how you felt and reacted to the subject and situation.

The study sketch

The study sketch is one that you will use for a definite purpose, either as it stands or as a working drawing for a finished piece of

Fig 6 People on beach. 4¼in. × 7½in. (11cm. × 19cm.)

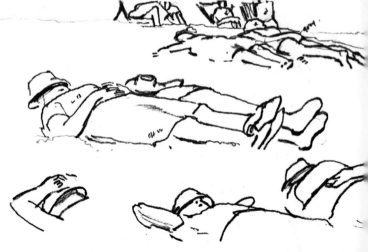

art work, a painting or maybe a sculpture. You may have a mental picture before you start of what you want the final work to be like, or you may go and look for a subject that you can turn into a finished picture. Your sketch will probably contain the elements of the finished work – its composition, notes on colour and the time of day, the source and direction of light etc. You may have to alter it slightly, rearrange parts or try them out in different permutations to fit the picture you have in mind, or it may only need squaring up and transferring to the canvas or paper on which you intend to carry out your finished work.

Fig. 6 below had to be adapted and incorporated with others before it was used for the beach scene painting on page 87; while the sketches of the Tiber bridge (fig. 40) and the Maltese landscape (fig. 48) needed little alteration, only enlarging and taking further, to develop into the watercolour painting of the Ponte Rotto on the Tiber (fig. 78) and the Maltese landscape print (fig. 46).

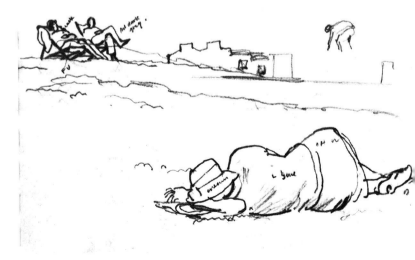

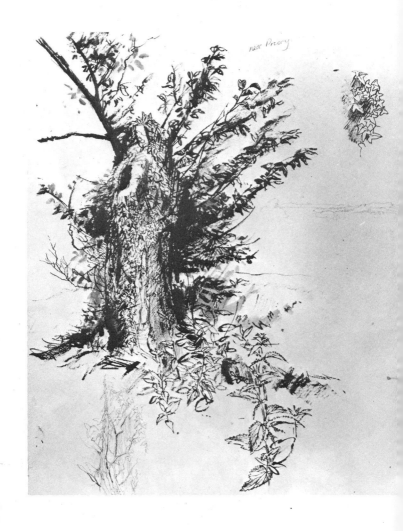

Fig 7 Old tree. 12in.×15½in. (31cm.×38cm.)

The practice sketch

When you start sketching you will have to train your hand and eyes to work together in a new way, and this takes time and practice. The eye sees, and the hand must try to record faithfully what the eye sees and how the mind interprets it. So you may find it valuable to set yourself practice sketches. Of course the subject you choose must interest you; there is absolutely no sense in recording something that doesn't stimulate you, and no merit in boredom and the diehard belief that if you don't enjoy it, it must nevertheless do you good. On the contrary, in the early stages of learning anything it can be disastrous to have to sit for hours doing something that doesn't interest you, and it can put you off the subject for good. So when you select your subject make sure that (a) it interests you and (b) it presents a challenge, whether by its form, intricacy, subtlety or nature, that will stretch your ability to the utmost. It is no help to make a study of something that is so simple it doesn't really merit the effort or so complex that you will not be able to master it.

Choose something that is difficult, but not impossibly so. Make several rough sketches of it first, until you are familiar with the general shape and proportions of the subject, and then make one or more really searching studies of it, possibly in different media. If at first you feel you are not succeeding, keep trying. You will learn a great deal about drawing, your own ability, and how to examine and search a subject so that you get the most you can from it.

It is advisable to do this sort of sketch in a large sketch-book or on paper so that you can work on a fairly large scale, and then you can see without effort what you are doing and get in plenty of detail.

In the sketch of an old tree (opposite), I used watercolour and a good sable brush which could give me the most delicate line or a broad wash of tone; it is a monochromatic study and I used the background foliage to give a dark tonal contrast to the old tree trunk with ivy climbing up it.

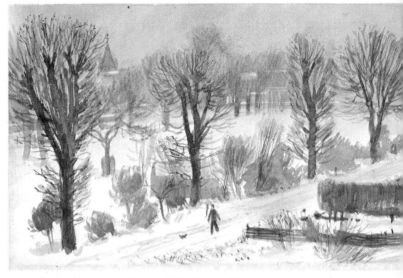

Fig 8 Snow scene. 10½in.×17½in. (27cm.×45cm.)

The statement sketch

This is the type of sketch that is an end in itself. You see something
–a scene or object that delights you–and you record it, in any
medium, in tone, line or colour or a combination of these. It is
a statement complete as it stands, evidence of your pleasure in
the subject, that you will keep, and perhaps frame, and which
will always remind you of that occasion and the feelings you
experienced then. This sketch will not have the notes and
visual 'shorthand' aids of the reference and study sketches,
because you are not intending to use it for this purpose but just
to create a picture; although later you may in fact develop it
further.

The sketch above was done from my window on a freezing
January day. There had been several days of snow and it was
hard packed by the car tyres on the lane, and drifting against the
grass and bushes; it was about three-thirty or four in the afternoon,
the light was fading and the sky yellowy-grey with more snow.
There was only one person out, the man exercising his dog. It was
the sort of afternoon when everything is still and quiet and it is
delicious to sit in a warm room and look out and paint a familiar
view that has completely changed in the incredible way it does
in snow; which was one of the reasons I did several sketches of
a favourite scene at different times on a snowy day (page 62).

Essentially the first two types of sketch, the reference sketch and the study sketch, are for the artist alone, they are his aids to work, and although we now publicly admire the sketch-books of great artists, they were originally intended as private things, done for personal reasons, either emotional or constructive. They were in no way conditioned by the thought that they would be seen by other people, which is something that must affect most finished works. I think it is very important to remember that sketches of these types are for yourself alone and, unlike a finished piece of work, should be judged by your own standards only; the criterion is whether they help or remind you as they were intended to, not what other people think of them. If there is to be any general criticism of a public sort it can be reserved for the final works that result from these sketches.

You will realize that, although I have defined sketching under these four main headings, the definitions will sometimes overlap: the practice sketch becomes the one you want to frame and keep because, although originally done as an exercise, it seems to have the quintessence of the subject you chose; you will also find that your study and reference sketches are used together.

The important thing is to be prepared for all eventualities. Subjects, ideas, stimulation are all around; everywhere you turn something may catch your eye, either perfect as it stands or a starting-off point for all sorts of avenues of exploration. So always have with you a small sketch-book and soft pencil, easily carried in pocket or bag. Just as many writers carry a notebook in which they write down a few words or paragraphs to remind them of a chance remark or situation which they might otherwise forget, so your small sketch-book becomes a visual reminder. If you haven't time to explore something that interests you, at least you can note it down as something to come back to. If you haven't got a sketch-book with you, make notes on anything available – an envelope, or a cigarette packet; all that matters is that you should get it down.

You will find that certain types of sketches and certain subjects sometimes seem to demand certain media, and you will also want to experiment, so in the next chapter I shall discuss the materials that should cover all of your needs without either overloading you or costing a great deal of money.

2 Equipment and media

Your first visit to an art equipment shop can be a daunting experience. You will find a bewildering range of different makes and types of colours, papers and media to choose from, half of which you have no idea how to use, and, unless you are lucky, there may be no one who can give you the really helpful advice you need about making the right selection. So here are some points to guide you into making a choice that should suit you and prove a good basic nucleus of materials that will be neither too cumbersome nor too costly.

First, go to a shop specializing in art materials, rather than a general store that just happens to have pencils and paper. Then, most important, select good quality materials; buying cheap or inferior equipment is a false economy, it will not have the same durability and may give disappointing results. Paints that have chalky, gritty colours, pencils that break easily, brushes whose hairs fall out and won't go to a nice point, paper that becomes like blotting paper, picks up in a pen or whose surface is spoilt when an eraser is used, are all most disappointing and can be avoided if you choose reputable makes; the assistant will advise you on these.

Basic equipment

Buy in small quantities to start with, you can always add later when you know what you need.

PENCILS AND ERASERS

Before you buy, consider what the materials will do. Pencils come in varying qualities of lead that range from hard (6H–H) to soft (B–6B) and this is stamped on the pencil. To give you an idea of the effects they produce, look at fig. 10 which was drawn with a hard, probably 3H or 4H pencil and at fig. 11 which was drawn with a soft pencil, 6B. I personally prefer a soft pencil as, by the pressure you put on it, you can produce a very light or very dark line and it is also good for shading either light or dark areas of tone; but a hard pencil can give you a tight controlled line and it doesn't smudge as easily as a soft pencil. So buy to start with a medium hard pencil, H or HB, and a fairly soft one, 4B or 5B, also a cased razor blade (less likely to cut holes in you or your pockets than a loose blade) or a small sharp penknife to keep a really good point on them. You may not need an eraser, but it is useful to have one; I generally use a kneaded or putty eraser as it does not leave any pieces or crumble, but if you prefer an india-rubber make sure it is nice and soft—or you can try an art gum eraser.

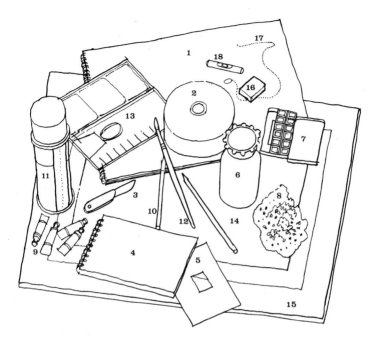

Fig 9 Equipment. **1** Large loose-leaf sketch-book. **2** 1½in. gumstrip (gummed tape). **3** Penknife. **4** Small sketch-book. **5** View-finder. **6** Plastic water bottle. **7** Tin of Artist's watercolours. **8** Natural sponge. **9** Tubes of Artist's watercolour. **10** Pencils. **11** Aerosol fixative. **12** Sable brush, size 9. **13** Palette. **14** Stretched paper. **15** Drawing board. **16** Eraser. **17** Plumb line. **18** Spirit level

WATERCOLOUR

If you already have some experience you may like to use oil paints as well as watercolours when you go sketching, but oil paints are slow drying and rather cumbersome and there is not space in this book to explain the technique of oil painting. Watercolours, with their quick drying quality, broad coverage and good transparent colours, are more convenient for carrying around and ideal for capturing atmosphere, colour and detail (see figs 8, 13, 14).

Whether you use oil or watercolour, choose *Artist's* quality colour. Cheaper ranges called Student and Economy colours are available but they do not give such good results; the pigment is less finely ground with the result that the colour is rather pasty and chalky, whereas Artist's quality colour has more finely ground pigment which gives smoother, more brilliant colour and also goes further.

Fig 10 Drawing of a farm cart done with a hard pencil (3H or 4H) on a slightly rough watercolour paper (Crisbrook Hot Press). Note the fine, controlled, tight line possible with a hard pencil but also that the tone range is not very great. 10in.×10in. (25cm.×25cm.)

Select just a few colours that go together well. The colour range available is enormous, but I generally keep a nucleus of four colours as I find these give me a pleasing range when used together, either as they are or mixed. I suggest you use these four colours to start with and then add to them as you become more experienced and discover your own personal needs. They are:

Fig 11 Rocky landscape in the Mediterranean, drawn with a soft 6B pencil on a smooth grey tinted paper (Stratheden Wove grey 22lb weight). A soft pencil travels more easily over the paper giving a freer line and quite a good tone range from light to dark. 4¾in.×9in. (12cm.×23cm.)

 rose madder (red)
 veridian green (when mixed with rose madder it gives a nice grey)
 french ultramarine (blue)
 yellow ochre *or* raw sienna

Avoid black; when mixed with colour it tends to dirty and deaden it rather than just make it darker.

 Watercolours can be bought in small tubes and these, together with a small enamel palette for mixing, are easily carried with you in your pocket or bag. You may also like to have one of the small watercolour sets with the colours in little square blocks; you can buy them with the colours already put in or, better still, choose your own, so that you can be sure of getting the colours you want. These small sets are also very handy as they fold away neatly for carrying.

BRUSHES

Brushes may seem expensive, but remember you cannot paint well with a poor quality brush. Choose a sable: it is the best one for watercolours, it is springy, holds paint well and comes to a nice fine point. Provided you look after it and do not leave it full of paint or standing point down on its hairs, it will last you a long time. If you make a long thin cone of paper to fit over the hairs, this will protect it. I use a size 9 which is quite a large brush, but I recommend it even for small work as it holds a lot of paint, the point gives you fine detail, while the side can be used for broad areas of paint and washes.

DRAWING BOARD AND GUMSTRIP (GUMMED TAPE)

Buy a drawing board (A2 size, 18in. × 25½in., 47cm. × 65cm.) for stretching paper on (see page 71) and for supporting loose paper, paints, palette, water etc; and a roll of 1½in. wide gumstrip (not a self-adhesive tape) for sticking paper down to the board.

PAPER

You will use your drawing board and stretched paper (see page 71) when you want to do watercolour studies and larger pictures. The best paper, I find, is either a hand made watercolour paper (ask for a 90lb weight paper which is heavy and strong) or a good quality fairly heavy cartridge (drawing) paper, these are both rather textured grainy papers ideal for most media. You will find that packing paper and the backs of envelopes, as well as a standard quality cartridge (drawing) paper, are all suitable for your practice sketches and cheap enough for you to use plenty without worrying about wasting it.

SKETCH-BOOKS

Sketch-books are most important and I suggest you have two, one small one about 7½in. × 4in. (19cm. × 10cm.), easily carried in your pocket or bag and used whenever you need it, and also a larger one about 14in. × 10in. (35½cm. × 25½cm.). Both should contain good quality cartridge paper; I prefer ones that are loose-leaf, spiral bound as they can be folded back into a block while working, and if you need to tear a sketch out for reference you can do so without risking the whole book falling to pieces as can happen with a bound book.

FIXATIVE, SPONGE ETC.

You will need fixative for spraying your drawings; pencil, charcoal, conté chalk and pastel all smudge easily. The aerosol type is

the simplest to use. You will also need a natural, not synthetic, sponge for washing out watercolours and a small polythene (polyethylene) bottle for paint water.

Variety of media

Now you have your basic equipment for drawing and painting. However, you will have noticed in the art shop that pencils and watercolours comprise only a small part of all the media available. It is a good idea, if you are starting on sketching, just to stick to pencil drawing and watercolours to begin with, but as you get more confident then you should experiment with other media, as they offer a variety of different and interesting effects.

When buying, the same rule still applies: get the best makes and buy a little at a time, don't spend a lot of money on large quantities as you may find that certain media do not suit you so well as others. You can and will build up a good working selection of your own favourites as you go along.

PEN AND INK

Pen and ink, whether black or coloured, are excellent for sketching, Pelikan do a very good smooth-running range of inks with bright colours that can give marvellous vivid effects. You can mix inks that are non-permanent with distilled water and paint them on in washes that go very well with a fine pen line (see fig. 5). The choice of nibs is very much a matter of trial, error and personal preference; buy one or two holders and a selection of nibs, these only cost a few pennies each. You may find you prefer to draw with a fountain pen, but remember in this case to use a drawing ink specially designed for it, as a lot of permanent or Indian inks are very dense and black and will clog a fountain pen. If you are using a brush with your coloured inks (fig. 16) try to make sure it is kept clean and separate from your watercolour brushes, as little particles of ink often remain in the brush and could spoil a watercolour painting.

CHARCOAL

Charcoal is a pleasant medium to use on either smooth or rough paper; it is excellent for big bold drawings (like the one on page 23) in both line and tone, cheap to buy in thin or thick sticks or contained in a pencil so that you don't get your hands covered with it, or free if you get it from the ashes of a fire! Remember however that it smudges very easily and has to be fixed (see page 20); and

be careful when spraying to stand back and apply a fine, even mist to your drawing, because if it gets a close direct shot it runs, and a dribbly charcoal drawing looks very sad.

CONTÉ

Conté crayon is halfway between charcoal and pastel, being denser and not quite so smudgy as charcoal but not so finely ground as a pastel. It is an oil bound pigment, usually black or terra-cotta brown, with a fairly coarse grain which gives a nice textured line with a certain bite to it, and it produces the best effects when used on a rough-grained white or coloured paper, even the rough side of packing paper. It is usually sold in short square-sectioned sticks and it must be fixed.

PASTELS

Pastels are very finely ground pure pigment moulded into sticks. They have brilliant colours but need quite skilful handling as they smudge so easily and are very friable (easily crumbled). You can get oil pastels which have more the quality of very good crayons and they hardly smudge at all. Both types have a very large and comprehensive range of colours, but rather than buying a box to start with, which can be expensive, select ten or a dozen loose pastels and see how you like the medium. Pastels look particularly good on a rough tone paper, say grey or green, but remember always to fix them.

FELT PENS

Felt pens have good strong transparent colours and are available in several thicknesses (see fig. 18). They have not the sensitivity and do not give the variety of line of pen and ink, but the advantage is that you do not have to carry a bottle of ink around or wait for the ink to dry; so try them, but use the watercolour type rather than permanent colour which makes cartridge paper act like blotting paper (unless, of course, you want that effect).

GOUACHE

Gouache is an opaque paint bound with gum and is mixed with water for painting. It is best bought in tubes, as in palettes or tins it tends to dry out and then you can't use it thickly and you may wreck your brushes by scrubbing them on the hard paint. It is a quick-drying medium but colours cannot be overlaid successfully as they can with watercolours.

Fig 12 Greenhouse plants. Charcoal, 19in.×26½in. (48cm.×67cm.)

ACRYLIC COLOUR
This is a quick-drying plastic bonded paint which, although mixed with water for painting, rather resembles an oil paint when on the paper, but once it is dry it cannot be dissolved, and if it dries in your brush you will never get it out. I would not normally recommend acrylics for outdoor sketching, I think you should experiment with them at home and then decide for yourself how and when it suits you best to use them.

WAX CRAYONS
Wax crayons can be bought cheaply, they have good bright colours and should not be thought of simply as crayons for children. Used on their own or with a liquid medium such as coloured inks or watercolour, with which they create a greasy resist, they can give you all sorts of exciting effects and textures.

Having set yourself up with the basic equipment listed on pages 16–20 (fig. 9), you need just a few more things, most of which you can make or find for yourself.

General equipment

First a plumb line – a small weight (a key, metal nut, heavy button) on a piece of string. Hold it up in front of you and it will always drop in a perfect vertical, enabling you to check all the relative verticals or near-verticals in your subject. I also carry a spirit level, a small one is quite cheap from Woolworth's and this will give you exact horizontals.

If you are working outside and it is likely that you will be sitting on damp ground, take a large polythene (polyethylene) sheet or bag to sit on; or you may prefer a folding stool.

Make a view-finder by cutting a rectangle out of a small piece of cardboard. If you hold this up in front of one eye it will 'frame' the scene you are sketching and help you in composing (page 55).

Finally, remember that when you are sitting still for a long time outside, you can get very hot or very cold (according to the climate or time of year), so dress accordingly. In cold weather lots of light, windproof clothing is best (I always tie a woolly scarf round my middle – not very flattering, but it keeps the draughts out). Take a thermos with a hot drink; hip flasks of brandy or rum are tempting but do tend to affect your finer judgement if not used in extreme moderation! – so save the winter warmer for a quick one on the way home.

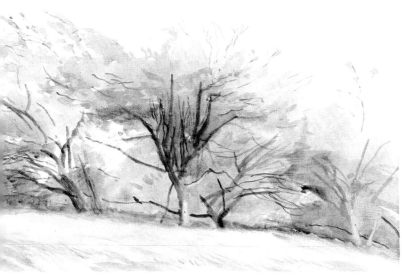

Fig 13 Trees. 11¾in.×17¾in. (30cm.×45cm.)
These two watercolour paintings show how suitable watercolour is as a medium for sketching (see also cover illustration). It is compact to carry, quick drying, and its broad coverage and transparent colours are capable of extreme delicacy or surprising intensity.
Fig 14 Welsh valley. 10½in.×17½in. (27cm.×44cm.)

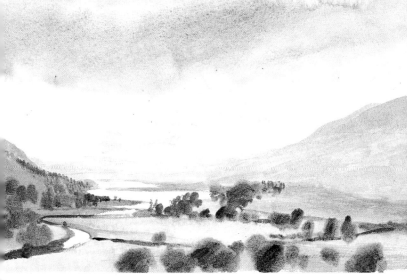

In summer, use a tinted paper rather than a white one, as it is not so glaring. Sunglasses should be shaded, not coloured, because coloured ones will change all the colours you see. Sit in the shade if you can; and it is a good idea to carry a tube of insect repellent with you.

Easels

You will see easels for sale in the art shop. They are expensive and rather complex constructions, and I personally never use one except when I am doing a large painting in the studio; when I am out I usually sit on the ground or anything suitable and prop the board or sketch-book on my knees. An easel that is light enough to carry easily may fall or blow over when erected on rough or exposed ground, and it is infuriating to be in the middle of a piece of work and have it, and probably your palette, water and brushes, all collapse. The great value of an easel is that you can leave your picture while you are working on it and stand back to look at it from a distance, although it is usually quite easy to prop your board against something if need be. However, buying an easel, and a folding stool, is something you can decide about later, when you have tried without; you may find life more comfortable with them and if you don't have to carry them too far they can be useful.

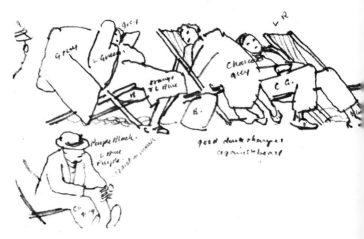

3 Choosing your subject

Why and how do you choose something to sketch? Simply because it interests you, and you feel an urge to record it.

I have a family of young children, so I draw them. Being small, they won't keep still for long, about ten minutes is the maximum for the eldest; this can be maddening but you have to accept it. I do lots of quick sketches, perhaps taking as little as thirty seconds, in which I try to capture an attitude, an expression, something that arrests a moment of time. Often I don't succeed; I expect failures, and I'm pleased when I do succeed.

Fig 15 Figures on the beach. $4\frac{1}{4}$in. × $7\frac{1}{2}$in. (11 cm. × 19 cm.)

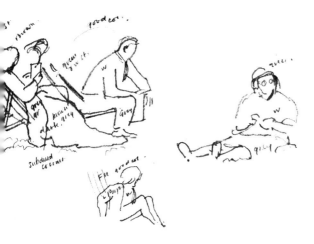

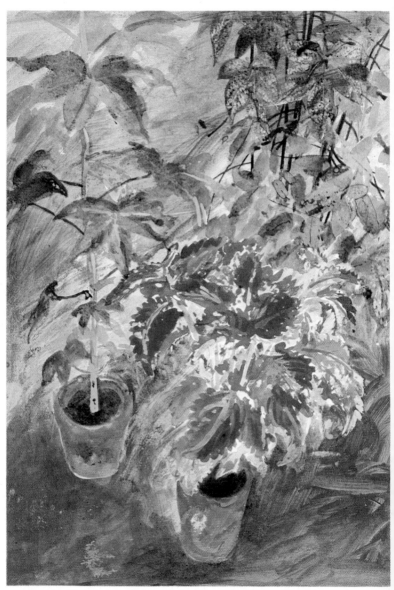

Fig 16 Plants in pots. Coloured inks, 19in. × 27in. (48cm. × 69cm.)

Fig 17 Child in chair. 10in.×14in. (25cm.×36cm.)

Your own family are a perfect subject, you know them well, they interest you, they are around most of the time and in constantly changing positions. However, if you are starting sketching and are full of enthusiasm it is wise to keep in mind that, although your nearest and dearest are generally willing to pose for a limited time, the younger they are the more limited the time will be; they soon become tired and bored sitting for ages in one position and may not be so willing to pose again. So try doing quick sketches, that will only take a few minutes; they are less tiring for the model and provide good practice for you as well as good material for reference.

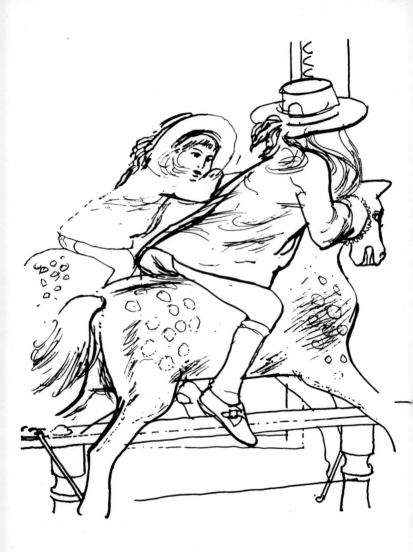

Fig 18 This sketch of my daughter, in fine felt pen on a smooth white paper in a large sketch-book, took about twenty-five minutes. She agreed to pose for longer than usual as she enjoys riding her rocking-horse, which is itself an attractive thing to draw, and she could look in the mirror and see herself and what was going on behind her. This is an example of how, with a little thought, one can incorporate interesting features in a picture (rocking-horse, mirror, Spanish hat) which will also make posing more enjoyable for the model. 11½in.×14in. (29cm.×36cm.)

30

Fig 19 Seated figure. 5¼in.×7in. (13cm.×18cm.)

Fig 20 Simple drawing of a whelk (mollusc) shell, basically a very simple object but interesting because of its beautiful subtle shapes and form and the delicate patterns of tracery on it. 2in.×3½in. (5cm.×9cm.)

I can't really tell you what you should choose to draw; as long as the subject interests you, then it is a good one for you. You may feel that still life is the thing, so you feel bound to set yourself up a still life group and draw it. However, don't feel that because you are starting to sketch you must do certain subjects because they are the 'done' thing; every subject is interesting, but not necessarily interesting to you at this particular moment, so forget what you feel you should do, and do what you want to do and what will give you the greatest pleasure. Once you get going you will find your interests widen, but don't put yourself off unnecessarily by attempting to do sketches of things that don't really interest you.

Ambition is a good quality in moderation, but again, you can get discouraged if, to begin with, you embark on too complex or elaborate a subject that will take you weeks to complete. To start with, choose simple subjects, one subject or a very small group that will not take more than an hour, or preferably less, to draw; and don't be afraid of making mistakes.

If you have not done any sketching before, start with something simple but attractive in your own home. First of all choose somewhere to work, preferably where you will not be disturbed, where your family won't keep coming every few minutes to have a look to see how you are getting on. Suggestions and remarks, such

as 'It doesn't look much like that, does it?' or 'What's that supposed to be?', which they may intend to be kindly or funny, are not much help and can be rather discouraging and annoying to a beginner.

So choose a quiet place and a simple object to begin with, a plain pottery vase with a few flowers in it, a piece of rock or twig or bone that is an interesting shape, anything you like as long as it is easily handled and fairly simple and you feel you want to draw it. Your actual method of sketching I shall discuss in the next chapter. It is, however, most important to make sure that the object is in a good light so you can see it really well. Have your source of light from the side or above; don't sit facing a window with the object between you and the window and the light coming straight at you, as it will hurt your eyes and throw the object into silhouette and you won't be able to see the detail.

Make sure that you are comfortable before you start, so that you can forget about yourself when you are sketching; any physical strain or discomfort will make you hurry to get the sketch finished instead of taking time over it and enjoying it.

When you have chosen the object you want to sketch, move it around so that you get it at the best and most interesting angle. I find it is a good idea to do a fairly detailed study from one angle and then other sketches, maybe detailed, maybe quite simple, from several different angles. In this way you will learn about and come to understand the three-dimensional form and the structure of an object rather than just one aspect of it. A flower drawn from underneath appears quite different from the same flower drawn from above, and yet the upper structure and form is dictated by the supporting underside.

Another important point, especially for beginners, is not to attempt to sketch if you are tired, as it demands concentration, energy and freshness; also don't work for too long, to begin with I should say an hour is long enough over one sketch, so choose something you can do in this time, and stop as soon as you feel your interest or concentration flagging. If you force yourself to go on when your eyes or mind are tired you will have a laboured drawing as a result, when the essential quality of a sketch should be its freshness and spontaneity. It is generally best to work for half to three-quarters of an hour and then stop for five or ten minutes, have a cup of tea or coffee, rest your eyes and stretch your limbs. Many people find it relaxing to listen to music either while they are working or at rest periods. By having frequent short rests you will keep the freshness of your sketch and also be able

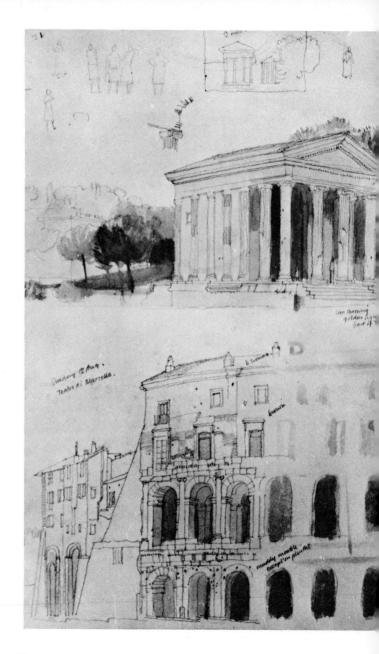

sun throwing
golden light
front of...

Sunday 12 Aug.
Teatro di Marcello.

brown

brown

muddy marble
exception plinths?

Figs 21 and 22 Temple and ancient theatre in Rome. I deliberately made the trees and figures hazy and atmospheric, and I used watercolour in monochromatic washes, drawing with a soft 4B pencil on rough watercolour paper to emphasize the crumbly textural qualities of the old stone. In large sketch-book, 11 in. × 18 in. (28 cm. × 46 cm.)

to go on longer. You will soon discover, when you have done more sketching, just how long your concentration will last and how frequently you need to rest.

It is not necessary to reproduce a scene exactly as it is, unless you particularly want to; the camera does this more efficiently and quickly than you can. The great joy of sketching is that you can select and emphasize the things that interest you or seem important. In a landscape sketch you can move trees around, enlarge hills, change colours, remove fences, just as you like, if you feel it will create a better composition. There are no hard and fast rules about sticking to nature and drawing things as they are if change or exaggeration will more successfully convey the way you feel and what you want to say about something.

As you get into the habit of sketching you will find that your own home and surroundings are full of subjects; there is no need, as many people imagine, to go out and find something to draw. Everything is a possible subject, it is just a case of saying to yourself, 'That interests me, I must sketch it'.

35

Fig 23 Simple pen and ink drawing on white cartridge (drawing) paper of the dried head of a globe artichoke. I have sketched in lightly the table it was on, to give a sense of place and also to counter the slightly isolated and top-heavy feeling it would have had on its own. 5½in.×6in. (14cm.×15cm.)

Subjects for sketching are endless, but here are a few ideas that you should be able to use and elaborate on to start with. At home the hub of most of our lives is the kitchen, and here you will find a large variety of interesting objects for still life groups. The objects that we handle and use each day provide a wide range of shapes and colour for the artist and, because of their functional quality, their shapes are generally pure, simple and pleasing. An added advantage is that most of these things are small enough to be moved around easily.

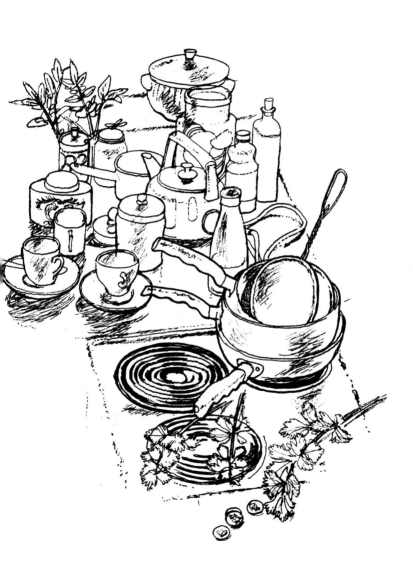

Fig 24 Still life of kitchen equipment. 10in.×14in. (25cm.×36cm.)

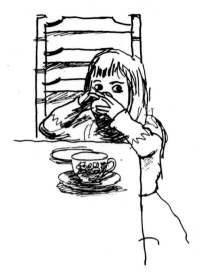

Fig 25 Child having breakfast. 5in. × 7½in. (13cm. × 19cm.)

The kitchen scene has always been a favourite subject for artists whether it be the family group at the table for a meal, as in the sketch of my eldest daughter having breakfast (fig. 25), or still life, food and general kitchen impedimenta, as in my drawing on page 37.

If you are selecting objects for a still life, avoid putting too much in, choose just a few objects or even one; a crowded group becomes confused and the special qualities of shape and colour that made you choose each individual item may get lost. Even though you may be thinking mostly in terms of form and colour, subject matter is still important, so try, as I have in figure 24, to relate the objects by association. A fine pair of kippers next to a packet of washing powder (detergent) and an egg whisk will produce certain visual unease, because there is no direct association between them; though each article has definite artistic qualities these get lost because of the overwhelming intellectual need to relate them in terms one is familiar with. If, for example, you put a globe artichoke with the kippers, or varied and colourful packets, jars and containers with the washing powder, and a bowl and crockery with the egg whisk, your intellectual reaction to the subject no longer puts up a barrier to evaluating it on its artistic and technical merits. For however much one tries to get away from it, the subject of a picture is what has the initial impact, and it is only when one has absorbed the subject content that one can start to appreciate the subtlety of composition and technique.

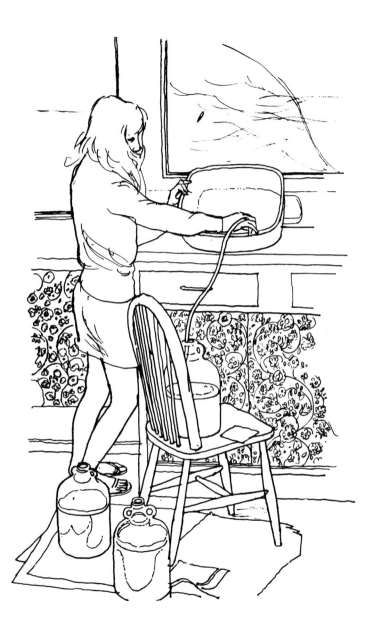

Fig 26 Siphoning beer in the kitchen. 11½in.×14in. (29cm.×36cm.)

So examine your reasons for choosing your subject and how to associate and arrange it. Just as a small area of complementary colour – say a patch of green in a predominantly red area – will emphasize the predominant colour, so a carefully selected contrast of line or form in a still life group will have the same effect: for example, a growing plant, herbs, or leafy vegetables among the geometric shapes of pots and pans will emphasize their rigid forms (fig. 24). Don't overdo this contrast, keep it small in relation to the whole so that it is accentuated; too much contrast will cause confusion.

Another point to remember when selecting your still life: make sure, if you want to spend several days sketching it, that your subject is not too perishable; fish, which are beautiful subjects to paint and draw, become high surprisingly quickly, and I had a friend who was in the middle of doing a fine still life of vegetables when someone ate his brussels sprouts and wrecked it!

Things from the kitchen are intrinsically associated with people, as found objects, plants etc, are generally not, so besides selecting your still life group and arranging it, sketch also things as you find them, as in figs 25 and 26. At meal times, sketch the objects as they are placed at random on the table, and the people round the table, handling things, eating, talking; this is perfect subject matter for endless sketches of all the four types I have mentioned in chapter 1. Also sketch someone working or cleaning or preparing food in the kitchen, as in the drawing (fig. 26) of my wife siphoning home-made beer. All these occupations give characteristic and interesting poses, although they are activities that are full of movement and so are often best expressed in a quick sketch.

Each room in the house offers subjects that reflect their own quality, which can be a help to you if you are wondering how to approach your subjects. In the sitting-room are the objects of choice, rather than of necessity as in the kitchen: the pieces of china and favourite vase of flowers make beautiful subjects for detailed watercolour or coloured ink sketches. Here people and animals are in a less transitory state, relaxing, watching television or sleeping in front of the fire, doing something that will keep them still for a reasonable length of time and give you your opportunity for a more detailed sketch that can take longer to do and yet still not necessarily require the model to sit self-consciously. Most likely your favourite objects on the mantelpiece or shelves are arranged in such a way as to create an attractive still life just as they are. In my sketch on page 28, done in coloured inks, the plants were

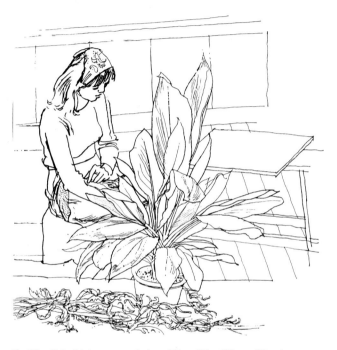

Fig 27 Girl with large potted plant. 13in.×13in. (33cm.×33cm.)

on a table by the window, giving marvellous colour on a dull wintry evening, and seemed to me the very embodiment of all the colour and richness of spring and summer.

Besides isolating one or more objects or a person to draw, sketch also the surroundings, a corner of the room with someone sitting in a chair reading the paper or a book, the patterned carpet the chair is on, the shelves or window behind, a complete area as you see it. In my drawing above I have made the focal point the great big potted plant and yet related it and the girl to their surroundings; and in fig. 28, a student reading in his studio, I have used the drawings of shapes and letter forms so that they

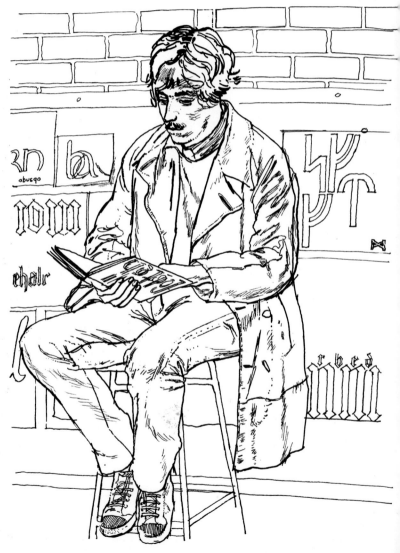

Fig 28 Boy reading. 11in.×14½in. (28cm.×37cm.)

provide an interesting background and also tell you more about the character, his interests and what he does. This is something you should remember and make use of in your sketches of people. The old masters made a point of including in the background of their portraits the things that tell us more about the sitter, either the tools of his trade or profession, or possessions that reflected his way of life. The background or surroundings of your subject will also give you good practice in relating different objects. Try, by the way you position and compose your subject and by the way you draw it, to create a main focal area of the part you decide is the most important (the boy in fig. 28, the plant in fig. 27), and then, by drawing in in less detail or more lightly, make the rest of your picture complement this area. If you give all the parts equal importance you may find that your picture lacks unity, with a lot of busy detailed areas all trying to catch your eye at once; this creates an uneasy feeling because, in the normal way of looking at anything, it is only possible to focus on one part at a time, and register it, and the surroundings are not observed with the same intensity.

Bathrooms and bedrooms are intimate sort of rooms that provide interesting subjects. Open the medicine cabinet, if you have one in the bathroom, and the assembly of bottles, jars and packets make a marvellous still life as they are. People in the bathtub are good subjects to sketch and paint; the enclosed shape of the bath dictates the position of the bather, as in my sketch over the page. Look at Bonnard's paintings of women in the bath, how the water changes the colour of the skin, and how he has emphasized the way in which water can distort and flatten forms so that the figure lying on the flat base of the bath, partly under water, seems almost two-dimensional. If you can persuade your model to pose in the bath, remember to keep the water nice and warm; don't be like Millais, who kept his model for 'Ophelia' posing so long that the poor woman caught a chill and died, because he was too absorbed in his painting to remember to add hot water!

In the bedroom, people dress, undress, do their hair, all in beautiful rhythmic poses that are a delight to sketch, and in sleep children, especially, offer a new aspect, as they are seen in perfect relaxation and you can spend time doing elaborate and detailed drawings that you might otherwise not get the opportunity for, as well as quick studies.

If you stand back a little way in a room and look out of the window, you will realize you are looking at a complete picture

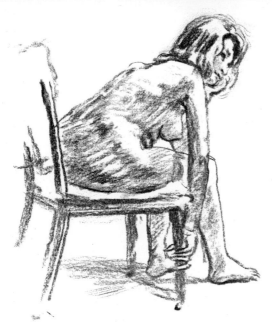

Fig 29 Charcoal drawing, 10½in.×12in. (27cm.×30cm.)

Fig 30 Girl in bath. 11½in.×14in. (29cm.×36cm.)

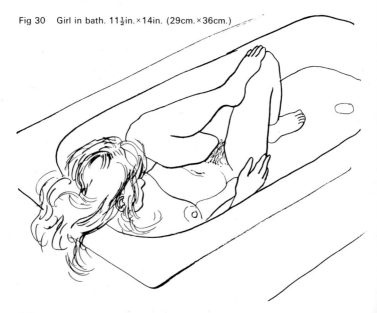

Fig 31 View from window across harbour, Malta. 12in.×16in. (30cm.×41cm.)

framed by the window itself. I drew the view of a little fishing harbour in Malta (fig. 31) from the bedroom of the house I was staying in, and made the balcony and the window catches, which were so attractive, the main decorative features in the drawing. You can also look in from outside, I love walking past houses in the evening when the lights are first turned on but the curtains not yet drawn. Each window contains a glowing set piece that has a tight composition contained by the contrast of the surrounding darkness, a picture that the people inside are completely unaware of but which, for the onlooker outside, has the same sort of visual excitement that you get when the curtain first goes up to reveal the stage set for a play.

If you have a garden shed or garage, notice how the lack of light gives a mysterious look to the objects inside, making them into strange sculptural forms. A potting shed or greenhouse, with its flower pots and growing things against the squares of the windows, is ideal for sketching. My drawing opposite was done in charcoal. It is very peaceful to sit and draw in the stillness of a greenhouse, with the air thick, warm and sweet smelling; but don't get too comfortable here, it is easy to go to sleep!

In your garden or back yard, domestic objects like dustbins (garbage cans) and wheelbarrows, useful utility things, become interesting objects in their own right as you start looking at them in the special way you learn when starting to sketch or draw or paint. You will see them as simple, heavy shapes emphasized by the light that falls on them, sculptural forms related to their surroundings. Look at Stanley Spencer's paintings, and you will see how he made everyday household things special.

Try lying a bicycle on its side out of doors (you need a good light for this), and then draw it. This is a challenging and quite difficult exercise ideal for the practice sketch, worth while for stretching your own capabilities and also for discovering the abstract qualities in a commonplace object. The spider-web tautness of the spokes within the ellipses of the wheels, the sinuous curve of the handlebars, the chunkiness of the pedals, the shapes of the spaces between the parts as well as the parts themselves, are all fascinating.

When you are out in the town, go to one of the local parks. Here, on the grass, on deck chairs, on curly-ended wooden seats, are people in all attitudes, sleeping, lying, resting, talking, walking, pushing prams, playing, in groups and singly, with children darting around among swings, slides and seesaws. If you are lucky enough to have a park with one of those delightful Victorian bandstands where the band plays on Sunday afternoons and sunny evenings in the summer, you will find material there for all kinds of work from the slightest sketch to studies for paintings.

On the beach, too, people form interesting groups and attitudes; the family with all its assembly of swimming and picnic things, children digging and making sandcastles, figures on stony beaches twisting in an effort to get both comfortable and brown, and the variety of near-nude figures ranging in type from classical nymphs to Rowlandson cartoons. Also on beaches you have fishing boats, sailing dinghies, rowing boats, pulled up away from the sea; and there may be winding gear and winches, lobster pots, nets drying or being mended by fishermen. There is endless material to be

Fig 32 Greenhouse plants. Charcoal, 18½in.×24in. (47cm.×61cm.)

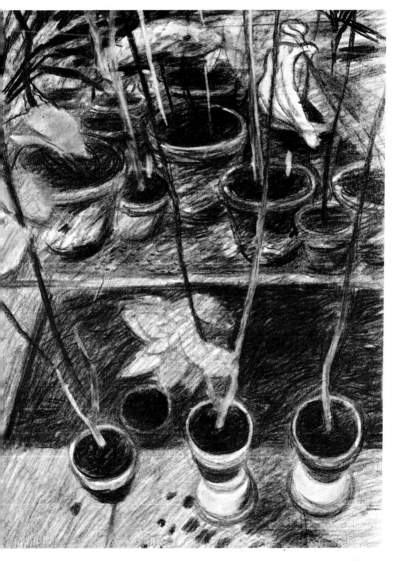

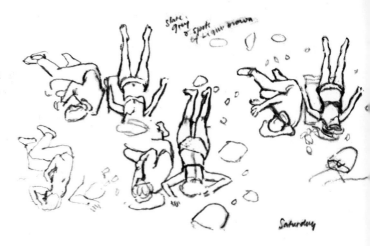

Fig 33 Figures on beach. 4¾in.×9in. (12cm.×23cm.)

observed and recorded, either as a quick sketch, or as studies for paintings or pictures for pleasure.

You will find after a while that many of these things, which you may formerly have taken for granted, now have a special nature of their own, a personal vernacular that is very strong, as robust and traditional as fairs and carnivals, and an essential part of the character of any country.

Fig 34 Beach and fishing boats. 4½in.×7½in. (11cm.×19cm.)

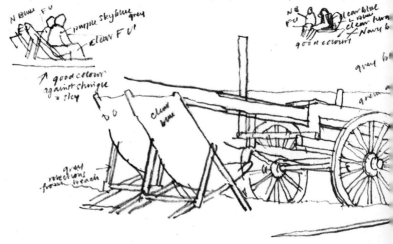

In the country natural things have their own beauty. There is a reassuring sense of permanence in old hills and slow rivers, water meadows with cows, farms, coppice and downland. You will find broad, sculptural areas to draw and paint, with only their surfaces constantly changed by weather and light, brooding and oppressive in thunder, luminous and floating in heat. In a gentle northern light this is perfect watercolour material, and water-

Figs 35 and 36 Two sketches done in Gozo, a small island close to Malta. The land, though fairly flat, is rough and broken up by lots of stone walls, giving this layered look; the buildings are golden stucco cubes and in every village pride of place is taken by the big domed church. The fishermen have big, pliable, tough bare feet

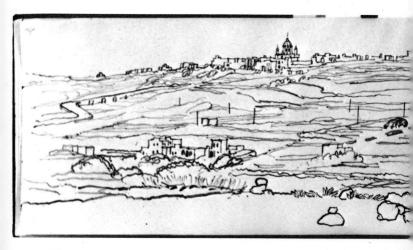

hooks to be baited.

Old
Board R. (Basket almost
same colour)
On pale gold wave ed

and hold the nets in their toes; these feet fascinated me! The lines spread in a wonderful tangle round the basket with the hooks poked through the rim ready for baiting. Soft pencil on tinted smooth grey paper in a small sketch-book; both 4¾in.×9in. (12cm.×23cm.)

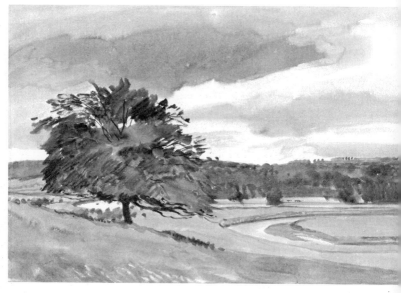

Fig 37 Watercolour landscape. 12¼in. × 18¾in. (31cm. × 48cm.)

colour seems to be a medium that might have been specially made for the atmospheric subtleties of the English climate.

When you go walking in the country or on the beach, look out for unusual objects, for example, strangely weathered drift-wood, a stone covered with beautiful moss or lichen, a bird's feather or the dried bones of a small animal; these *objets trouvés* can be taken home to be drawn and sketched and you may find as I do that they are so beautiful, with their sculptural forms and decorative, textured, coloured or semi-transparent surfaces, that you will want to keep them about the house to be handled and enjoyed. I have a huge vase full of dried flowers, sea holly, skeletal cow parsley, honesty, sunflowers and globe artichoke heads, which gives constant pleasure and provides endless inspiration for sketching. On shelves and mantelpieces I have stones, crab shells, mother-of-pearl oyster shells, mollusc shells covered with

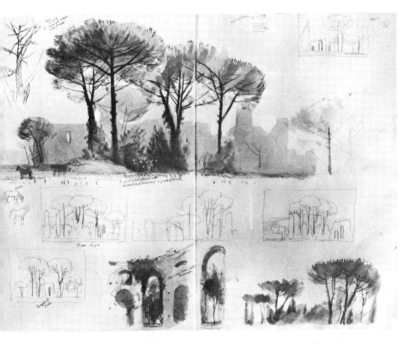

Fig 38 Landscape with umbrella pines, Rome. 11in.×18in. (28cm.×46cm.)

barnacle tracings, pieces of bone and wood that I have picked up and can't bear to throw away because of their beauty.

As I have said, the choice of what to sketch must be a matter of personal preference and of what interests you at any one time. I have touched on just some of the subjects you will find around you that could, perhaps, be the catalysts that trigger off a line of pursuit you had never dreamt of. When you have chosen something that really interests you, try to get the most out of it, explore it, so that in learning about it you teach your eyes to see in a new way, and tax your ability to the fullest extent. It is not easy; nothing that has great rewards is; but by constant practice you will learn to express nature and your surroundings in a personal way that will broaden your outlook and experience and give you constant joy.

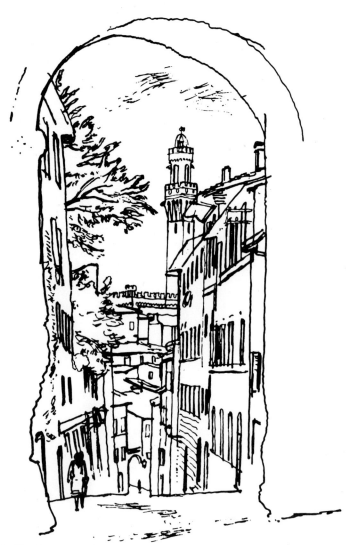

Fig 39 Doors, arches, gateways, like windows (see figs 31 and 65), can be used to frame a composition; this scene through an archway in Siena was drawn in pen and ink on cartridge (drawing) paper in a large sketch-book, 10in.×14in. (25cm.× 36cm.)

4 Observation and technique

Once you have selected what you are going to sketch and are faced with a scene, a figure or an object in front of you and a blank piece of paper or a sketch-book on which you want to draw, it can be difficult to know how and where to start.

Observation and composition

First of all, look at your subject thoroughly; if possible examine it from all angles, making sure the one you have chosen to sketch is the best one. If the subject is too big for this (for example, a street scene or landscape) and you are finding selection difficult, you can use the view-finder mentioned in the chapter on equipment. Hold the piece of cardboard up in front of one eye, close the other eye, and you will see that the rectangle cut in the card 'frames' your picture; by moving the card around, nearer, or further away you can eliminate distracting surroundings or detail and can isolate and position the parts of the subject you are interested in.

When you are composing a picture, remember that the relationship of objects to one another is important, so experiment either by moving the different parts around, if they are small enough to handle, or by doing several small experimental sketches, until you feel that not only the subject but also its arrangement is visually interesting. The shapes around and between things play an important part. When drawing or painting on a sheet of paper or on canvas you must relate the composition as a whole to the four edges of your paper so that it fits comfortably within this area. In your sketch-book it is not generally necessary to compose your picture in relation to the page area; you are more likely to be interested in recording the subject as a thing on its own for reference or study purposes, to be used at a later stage in a composition.

When you have studied your subject thoroughly, make sure you understand it and how it works; if it is a growing thing, see how it thrusts up, how the stem or trunk supports it and bursts out into flower or leaf. A tree has as much beneath the earth as above, the root structure is really like an inverted underground tree. If you are drawing figures, make sure that they stand or sit firmly; check with the plumb line the exact position of head, shoulders etc. in relation to the body and feet; you will then avoid the common mistake of making the figure look unconvincing or even as if it is about to fall over.

Perspective is something that worries many people, I think

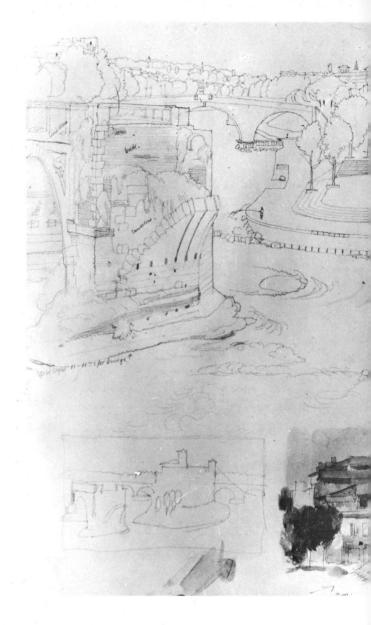

Fig 40 Ponte Rotto, Rome. 11in.×18in. (28cm.×46cm.)

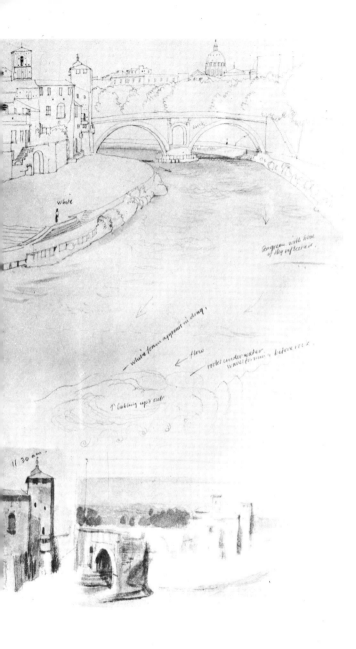

white

sea green, with blue
of sky reflected.

white foam appears in doing.

flow

rocks under water.
water foaming before rock.

bubbling up & out

11.30 a.m.

Fig 41 Tree drawing in monochrome watercolour on a rough watercolour paper; tone and line are used to convey mass, tension, delicacy and intricacy. 9in.×6in. (23cm.×15cm.)

quite unnecessarily. It is not very important, and if you make sure that your horizontals and verticals are accurate, and compare the height, width and depth of the objects you are drawing, one with another, you will be perfectly all right and can forget the mysteries of mathematical perspective — which not many people understand anyway!

If you are drawing an object, make it solid and convincing. The base line often appears thicker as there is a line of shadow under it; showing this in your drawing will stop the object 'floating' and give it weight. The shadow an object throws can be as important as the shape of the object itself, and by showing areas of shade, shadows and highlights, you can give your drawing added conviction. Shading is done by building up the texture of lines as I have done in the study sketches in figs 49–52. Make your pencil strokes follow the changes of contour so that as well as indicating shadow they also emphasize form.

Line and tone

Broadly speaking, there are two main techniques of drawing: line and tone. (I am not considering colour at the moment, for unless it is used in a linear way, it is in a sense secondary, a superficial coating over objects. If you remove the colour, the objects are still recognizable, but if you remove the line and tone and leave the colour on its own, you will have a lot of shapes with little or no meaning other than as areas of colour.) Most objects can adequately be described in terms of line or tone. Line defines the visible edges of things and to a certain degree the patterning or detail, and can be quite adequate on its own without the use of either tone or colour (see, for example, figs 2, 26, 28, 40, 42).

Tone is areas of light and shade that convey the mass, depth, solidity and three-dimensional qualities of objects in terms of either graded shadow or contrasted light and shade. Tone can also

Fig 42 A very simple line drawing, but a complete statement as it stands; charcoal on cartridge (drawing) paper. 9½in.×12in. (24cm.×30cm.)

show the play of light on objects and water. However, although tone can be used entirely on its own, it often needs line with it to make the drawing more explicit.

When you start sketching, look for the general shape and mass of the subject; half shut your eyes, and this will cut out a lot of detail and make it easier to see the areas of light and shade and simplify the shapes. Sketch these in in line and tone, using your soft pencil as it covers the paper easily and is best for shading with. Keep checking; use your plumb line, held at arm's length, to show you exact verticals and angles in relation to the vertical; check the size of one object in relation to another so that the proportions are right; for instance, when drawing a figure, measure how many times the model's hand goes into the arm or how many arm-widths there are across the body. You are quite entitled to change things if you feel it will improve your picture, but make sure it is done on purpose and not accidentally.

It is very important to sketch your subject as a whole and keep all the parts of the drawing going at the same time. If you concentrate on one area and draw it in detail before you have done the rest of the picture, it will throw the rest of the picture out of gear; the whole sketch must grow together. Allow your pencil to

move freely over the paper, and don't be afraid of making mistakes. If you don't make mistakes you will not learn, and if you are worried about them your whole attitude and approach will become tense and nervous and you will produce a tight, laboured drawing. As a general rule, don't rub out; try to absorb your errors into the drawing, or, if it has really gone wrong, turn the page and start again.

When you have filled in the general shape, mass, and light and dark areas of your sketch, you can then concentrate on detail. When you look at anything, you see most clearly the part nearest to you, so make this the most detailed part of your sketch. If you are drawing a field with trees at the far end of it and hills beyond, keep your detailed drawing to the foreground; if you indicate this foreground only roughly and put a lot of detail into the trees in the middle distance, the trees will jump forward and distort the feeling of distance. The hills in the background can be treated in tone only, so that they give a feeling of solid mass at the back of your sketch.

Fig 43 Fisherman. 6in. × 9½in. (15cm. × 24cm.)

Colour

Colour is not only related to a subject in the sense of dark and light, it also conveys warmth, coldness, atmosphere, and information about the subject as well as being an experience in its own right. According to the mixture of pigments, colours can be warm or cold; for example, a lemon yellow is acid and cool, a marigold yellow is bright and hot, a yellow ochre dull and warm; all yellows, but in different shades which convey different feelings.

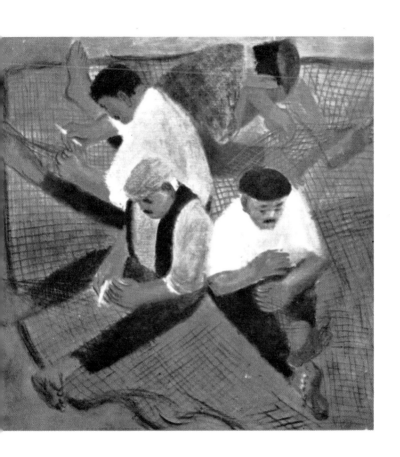

Fig 44 A painting of fishermen done from many studies, and using the nets as strong swirling shapes to give rhythm to the composition and link the figures. Oil on hardboard, 38in.×38in. (97cm.×97cm.)

D*

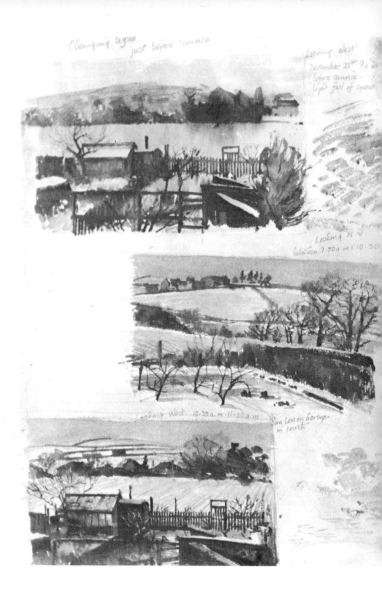

Fig 45 These sketches of two slightly different views were done from the same window, during the course of one day and the beginning of the next. They show the constant change and variation in a single familiar scene, especially under snowy conditions when the sense of drama in a landscape is intensified. 12in.×15½in. (30cm.×39cm.)

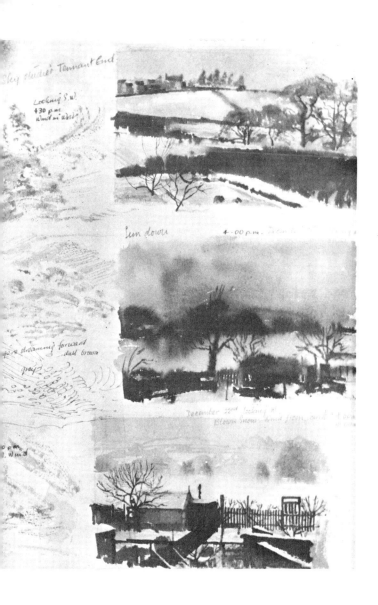

Sky studies Tennant End

Looking S.W.
4·30 p.m.
Wind in West

Sun down 4·00 p.m.

clouds streaming forward
dull brown

grey

December 22nd looking at
Blown snow

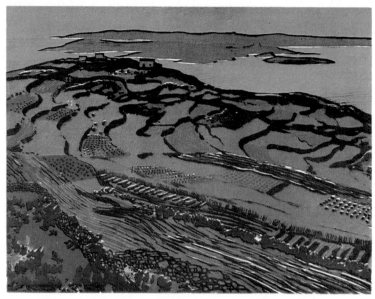

Fig 46 Maltese landscape. Lithograph, 17½in. × 23in. (44cm. × 58cm.)

Fig 47 Hermitage Castle, Scotland. Lithograph, 17½in. × 23in. (44cm. × 58cm.)

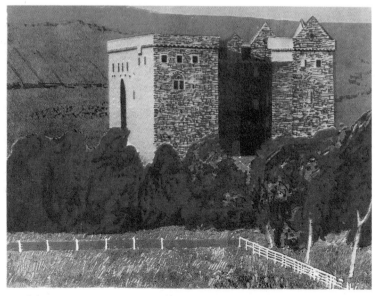

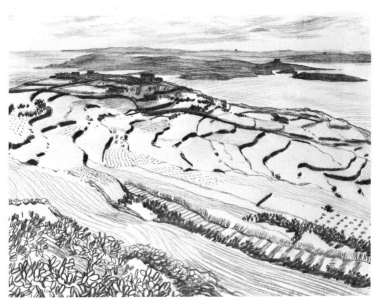

Fig 48 Large drawing of a Maltese landscape, an example of a study sketch that was transposed almost exactly as it was to make the print opposite (fig. 46). Charcoal on cartridge (drawing) paper, 18½in.×24in. (47cm.×61cm.)

Whatever your subject, choose colours that relate to or complement each other, either by their similarity (e.g. warm-toned colours, such as orange, warm green, red, brown etc.), or by their contrast as in fig. 46 where the cold blue of the sea and sky intensifies the feeling of heat in the brown and purple land.

Keep your range of colours fairly small. Decide whether the subject is hot, cold, cool or warm and choose your colours accordingly. For the print of the Maltese landscape (fig. 46) I used only three colours, burnt sienna, peacock blue and magenta; and for the print of Hermitage Castle (fig. 47) I used magenta, orange, light green and burnt sienna. Remember that a spot of brilliant colour strategically placed, as the fence in fig. 47, can emphasize the nature of the other colours.

Concentrate first on getting rid of the white paper with broad areas of tone or colour; white paper affects all the colours, and unless you decide to leave it as part of the picture in its own right (in the sky, for example), it is best covered, even if only with a very thin layer of neutral paint, as pure white is so bright and dominating.

Figs 49–52 Four stages of a drawing of shells, 9in.×4in. (23cm.×10cm.)

Note how at all stages each part of the drawing has been developed at the same rate; the sketch has grown as a whole, and in this way the relationship of the shells and the whole composition is kept balanced and unified

Stage 1 Draw in the main shapes, checking their relationship to one another and the space they occupy.

Stage 2 Draw in tonal areas and shadow; note thickening of line where the shells rest on the flat surface.

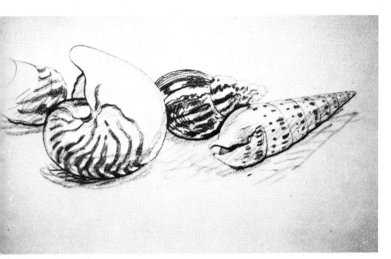

Stage 3 Draw in main pattern areas and general detail.

Stage 4 Completion of drawing; strengthen all the areas of line and tone where necessary, draw in final detail, emphasize and link areas of tone and shade where necessary.

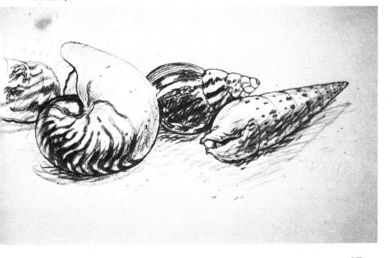

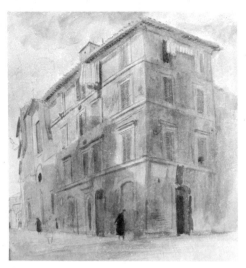

Fig 53 Trastevere, Rome. 11in.×12in. (28cm.×30cm.)

Build up your colours gradually, washing out if necessary. You will find that colours change when other colours are put next to them; some will recede, others will come forward, some will emphasize or detract from others; certain colours will jar together unpleasantly, others will blend and complement. For this reason, if you are working in watercolour, use to start with just the four colours I mentioned on page 19–rose madder, veridian green, french ultramarine (ultramarine blue) and yellow ochre (or raw sienna)–as they go together and mix pleasantly. Later, as you get more confident, experiment as much as you can; you will find that you develop a personal preference for certain colours and build up your own personal colour sense. Don't be afraid to experiment and make messes and mistakes; watercolour and water-based inks can generally be washed out with a sponge.

If you allow one transparent colour to dry and then paint another transparent colour over it, you can change the qualities of colours in the most varied and subtle way and also make them very rich and luminous. This treatment is called glazing and can be used with watercolour and coloured inks, and with oil paint. I used it, together with drawing in watercolour, in the painting shown in fig. 53 to try and get the sultry brilliance of a hot afternoon sun on aged stucco and ochre-washed walls in the old quarter of Rome. You can also get attractive effects in watercolour and coloured inks if you try combining them with a greasy resist like wax crayons or a candle. I used candle wax in the sketches in watercolour of the sea (fig. 54) to give a watery, foamy effect.

Fig 54 Seascapes. Watercolour and wax, 11in.×17½in. (28cm.×44cm.)

Fig 55 An example of when to take only a small selection of materials with you:
I had to climb over wharves, ropes, and boats to get onto the deck of this boat, which
would have been difficult with a lot of equipment to carry. 4¾in.×9in. (12cm.×
23cm.)

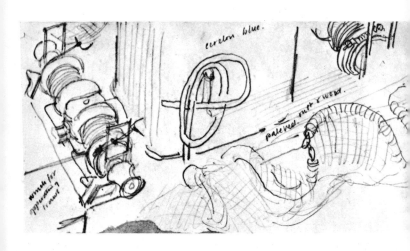

If you are using opaque colours such as gouache, mix the
colours on a palette before painting them on, as you cannot blend
them by glazing. If you want to overpaint, let the first layer dry
thoroughly and then be careful not to stir up the paint underneath.

Pastels, oil pastels and wax crayons, which are all semi-opaque,
can be used in a linear way or as areas of flat colour. With pastels
especially, colour mixing is more difficult as they smudge so easily;
you can with care overlay colours, but don't rub them to mix them
together as this will deaden the bloom and sheen which is the
essence of pastel colours. To be most effective, the colours are
best used individually, and pastel drawings must always be fixed.
Oil pastels and wax crayons can be used more freely, mixing,
overlaying, combining them with watercolour or coloured inks,
as they do not smudge so easily.

If you are working at home you will have all your materials at
hand, but if you are going out to sketch it is wise to plan in
advance what you want to do and the media you are likely to
need. If you are not sure, take a small selection which will cover
most of your immediate needs (see 'Basic equipment', pages
16–20), otherwise you will either be burdened with a lot of
equipment, most of which you won't need and which can be
heavy to carry, or you will arrive at the right scene with the wrong
equipment and not feel able to sketch it in the way you want.

70

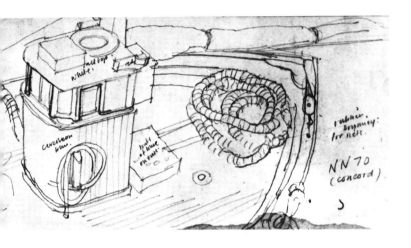

STRETCHING PAPER FOR WATERCOLOUR

If you want to do a large study in a certain medium, either as an end in itself or as a study for a painting to be carried out at home, or you want to use watercolour or inks in a quantity that would make loose paper buckle or curl with the wet, take with you a drawing board with paper stretched on it. This will give you a nice flat paper surface for working on which will not move, curl, or blow about; and providing you use a good quality paper such as the 90 lb-weight watercolour paper mentioned in chapter 2, properly stretched, you can paint and wash out and overpaint all on the same surface and it will remain flat even when thoroughly wet.

The method for stretching paper is quite simple, but you must do it the night before you need it. First of all, soak both sides of your paper for five minutes in a bath of cold water. Wet the surface of your drawing board so that it does not absorb the water from the wet paper too quickly, and then lay the paper on the drawing board. Using a natural sponge, sponge the paper outwards from the centre to remove excess water and push out the air bubbles from between the board and the paper. Stick $1\frac{1}{2}$ in.-wide gumstrip (gummed tape) all round the paper, with a $\frac{1}{2}$ in. overlap onto the board. Rub it down to make sure it has stuck well. It is important now that the paper should dry slowly; if it dries too fast it may

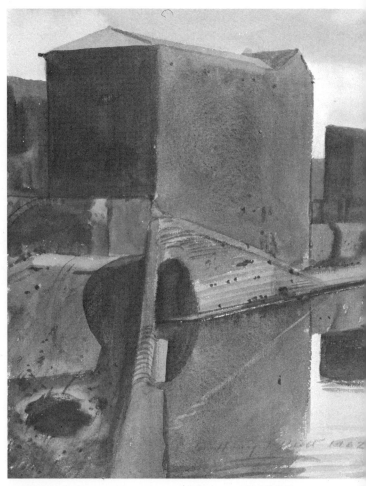

pull away from the gumstrip, or split, so be sure that it is away from direct heat such as a radiator or sunshine. Place a wet sponge in the middle for the first hour. In the morning you should have a perfectly smooth, flat, hard surface for working on. You can stretch paper on both sides of your drawing board.

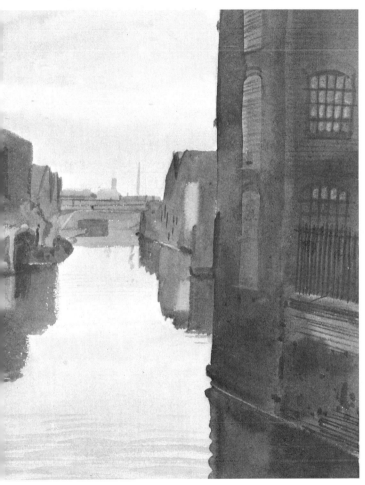

Even if you are working on a large sheet of paper in a dry medium, I think it is best to stick the sides down with gumstrip (gummed tape) and then you don't have to worry about the paper moving or the wind blowing underneath it.

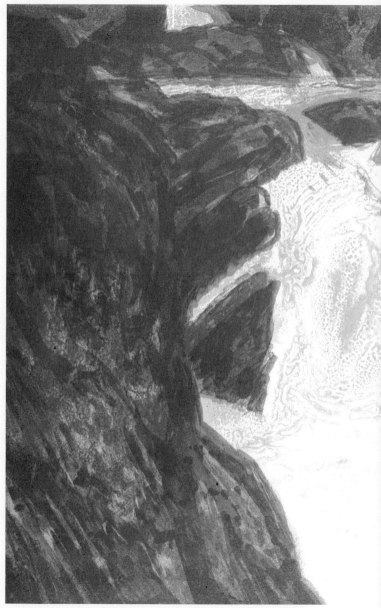

Fig 57 Waterfall. Lithographic print, 18in.×24in. (46cm.×61cm.)

Fig 58 Tree. 12in.×15½in. (30cm.×39cm.)

Mass and detail

When you have selected your subject to sketch and have studied it carefully, look for the things that give it its particular characteristics and qualities, because these are the points to emphasize and, if you feel it necessary, exaggerate. If, for instance, you are drawing rocks or stones that are brooding and massive, use charcoal or a very soft pencil and express them mainly in areas of tones; and if the light catches them, make the contrast between light and shade very strong. In my picture of a waterfall (fig. 57) the water is light and rushing compared with the dark mass of the rocks. Make your drawing harsh, powerful and vigorous, and make use of contrast; for instance, a delicate piece of grass or lichen drawn in fine line in the foreground will reinforce the solidity and harshness of the rest.

If you are drawing trees and want to make a feature of the delicate and intricate patterning of leaves and light and shade, draw them in line, or in colour and tone used in a linear way, or in dabs of colour like pointillism; make this area busy and vibrant with texture, change of tone, and detail, as in my sketch opposite. But if you are putting in the surrounding area, keep it very simple and flat so that it complements the detailed part of the sketch rather than arguing with or detracting from it.

Texture

Texture is another thing to look for, it will tell you how things feel, whether they are soft or prickly, rough or smooth, or even, by association, warm or cold. It also helps to express form.

If you are drawing your cat or dog, notice how you are more aware of the pattern of hairs where the surfaces change plane: where the leg joins the body, round the eye socket, on the paws. As you draw, emphasize the hair growth, its direction, whether it is tufty or curling or smooth, how it expresses the form underneath. In my watercolour of circus ponies (fig. 59) I have tried, by scrubbing the paint on, to show the thick rough warmth of the little Shetlands' coats. Texture used in this way will show what the animal feels like to handle and will also help in portraying its character.

Textures are well worth trying to express for their own sake in things like the scales on fish, the roughness of bark, the hard shininess of glass. Use a well-sharpened hard pencil, or pen and ink, for the sharp, spiky or delicate things: a large thistle, a bird's skeleton or feather, a delicate flower or seeding grass head (see

Fig 59 Circus ponies. $11\frac{1}{4}$in.×$18\frac{1}{4}$in. (29cm.×46cm.)

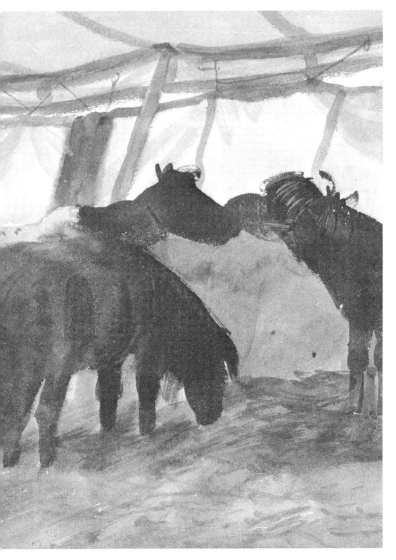

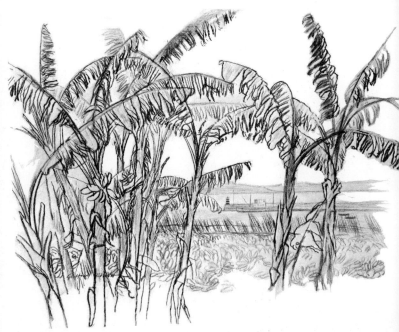

Fig 60 Banana plantation. 17in.×29in. (43cm.×74cm.)

figs 20 and 23). Use soft pencil, charcoal, conté, for soft rough textures or big tonal areas. In this way you are using your medium to suit the subject and not simply as a method of recording. With a little thought beforehand this can produce studies, either simple or detailed, that are more satisfactory because you have taken into account the special qualities of certain media and how these qualities can be exploited to express more about the nature of the subject.

Paper also comes in many textures and these should be tried and experimented with. Coloured inks or pen and ink go well on a very smooth white paper that has a fine coating of china clay or has been hot-pressed to give it a hard white gloss. Coarse or friable (easily crumbled) media like chalk, pastel, conté etc. are well suited to a grainy paper which will emphasize their roughness.

If you use a coloured paper, choose a neutral shade or you will find it is too insistent and argues with the colours you use; brown packing paper is quite good to draw on. You will be surprised to find what a lot of different types of paper there are

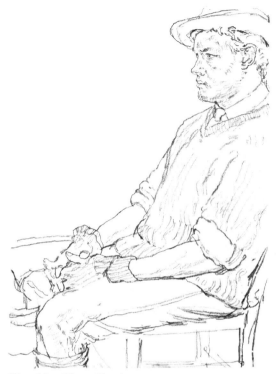

Fig 61 Workman. 10in.×14in. (25cm.×36cm.)

in a well-equipped art shop. It is a good idea to experiment with all types and discover what various media will do on them, you will find you can get some interesting effects.

Observation and judgement

You can become so interested and involved while working that it is often difficult to view your own work objectively, and unless you are constantly on the watch it is possible to make considerable misjudgements and not notice them. As you draw, check constantly relative sizes. As I said earlier, compare the height or width of various parts with one another, also check details, verticals and horizontals by use of the plumb line and spirit level. Prop your work up and stand back from it frequently, in this way you will be able to see how it is working as a whole. When painting a landscape, it is quite a good idea (unless you find it physically impossible!) to turn your back on the view, bend over and peer at it upside down between your legs; this may sound crazy, but in

Fig 62 Venice. 6in.×9¼in. (15cm.×23cm.)

fact it is a very good method of disassociating the literal qualities and details of the things in your picture and seeing them freshly just as shapes. Or you can turn your picture upside down, and again you will be able to see it as an abstract composition of shapes rather than strongly associated objects. The second method of examining your picture is the most advisable for use

Fig 63 Venice. 6in.×9¼in. (15cm.×23cm.)

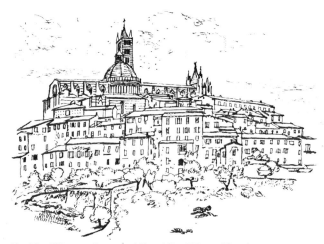

Fig 64 Hill town, Tuscany. 10in.×14in. (25cm.×36cm.)

in towns, or you will find you attract an even bigger crowd than
is normal for an artist, unless you can manage to be discreet or
pretend you have dropped something on the pavement! This is
a particularly useful way of seeing if a painting works, because
in painting you are composing in colour as well as tone, line and
form.

Fig 65 Stone entrance and steps, Malta. 4¾in.×9in. (12cm.×23cm.)

Fig 66 Maltese fishing boats. 4¾in.×9in. (12cm.×23cm.)

Fig 67 Maltese boats. Lithographic print on white, 17½in.×23in. (44cm.×59cm.)

At home, besides turning your picture upside down, you can hold it in front of a mirror which surprisingly makes it look quite different, and enables you to see your composition freshly and objectively. You can also do this when arranging a still life, by holding the mirror in front of the group and looking into it obliquely, or by holding the mirror in front of you so that you can see the still life behind you; in this way you can see if the position and relationships of the shapes are right.

If, as often happens, you know something is wrong somewhere in your picture, the balance feels uneven or the composition seems fragmented and not working together, but you don't know exactly what is causing the trouble, leave it for a while; have a cup of coffee or walk around, and then come back, look at your picture again, turn it upside down if necessary, and now that you are refreshed you will be able to see what you must do to put it right.

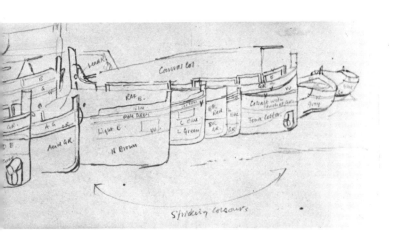

Striking colours

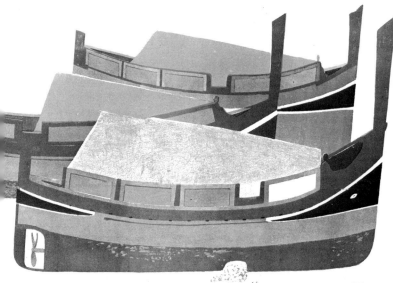

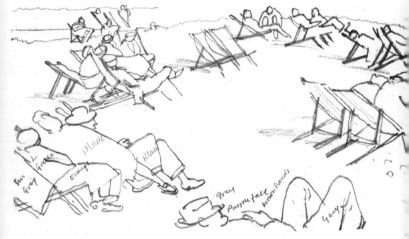

Fig 68 Beach scene. Sketch, 4¼in.×7½in. (11cm.×19cm.)

Maybe you have used too strident a colour in the middle distance so that it jumps forward, and you will have to tone it down by overpainting; or you have put the emphasis in the wrong part of the picture, instead of placing it where it will balance with and unite the other parts, so you will either have to counteract this by placing more emphasis somewhere else or reduce the strength of this dominant area.

Always have a pause and a fresh look, before deciding you can take a sketch no further or pronouncing it finished. Bringing a sketch to a satisfactory conclusion is not easy and it takes patience, thought and self-discipline to change and remove things that aren't working even though you feel they are particularly attractive in themselves. All that may be necessary to bring the picture together is the cooling down of an area of hot colour by overpainting, or more detailed study in the foreground. Cover up different parts of your picture one at a time with a small piece of card, this will help you to isolate and deal with any parts that aren't working. Even apparent disasters can often be remedied by quite simple treatment and the courage to go on when things seem to be going wrong.

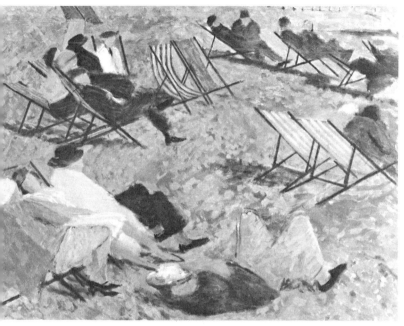

Fig 69 Beach scene. Oil painting, 30in.×40in. (76cm.×102cm.)

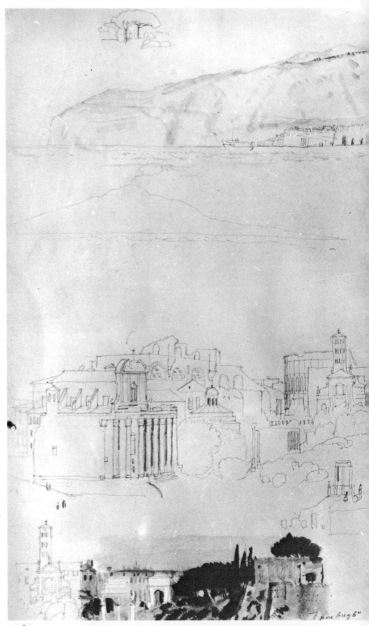

Fig 70 Sketches done in Rome and Sorrento. 11in. ×18in. (28cm. ×46cm.)

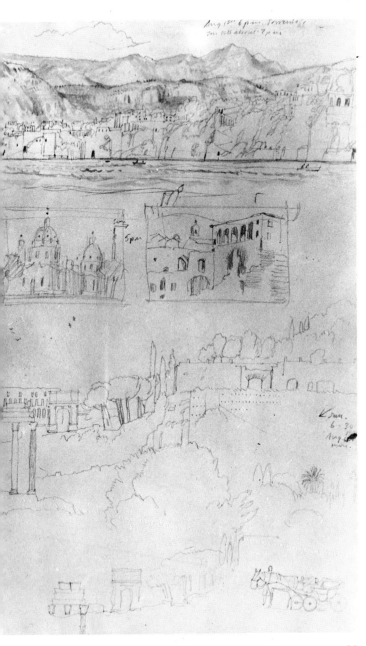

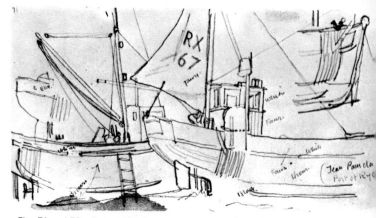

Figs 71 and 72 Experimental compositions in sketch-book for painting in fig. 73.
4¾in.×9in. (12cm.×23cm.) and 10in.×12in. (25cm.×30cm.)

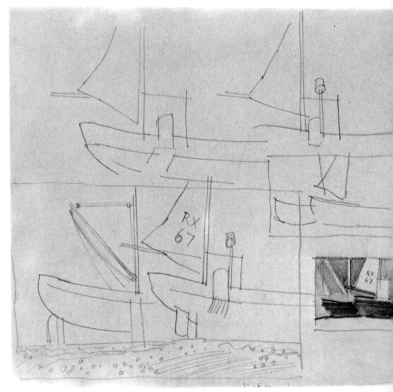

5 Using your sketches

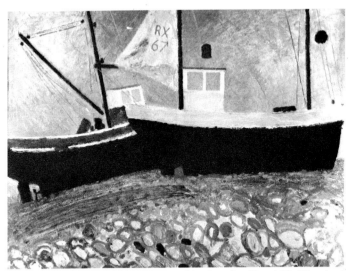

Fig 73 Painting of Rye fishing boats resulting from figs 71 and 72. Oil on hard-board, 30in.×40in. (76cm.×102cm.)

When you have completed your sketch and, if necessary, fixed it, you may want to leave it in your sketch-book or in a folder, an exercise completed or a recording of something that interested you. Alternatively you may have done it deliberately as a study for a larger work, or you may find that the sketches you made for general reference you now want to transpose into a composition.

The chances are that your study will be smaller than the picture you want to do, and although you can copy from the sketch direct onto your large paper or prepared hardboard or canvas, the most accurate method for enlarging and transposing your sketch is by squaring up. The method for this is described on the next page.

If you decide to do a composition that will use material from your sketch-books such as a group of people, some boats, a group of deck chairs, sketch out your composition roughly on paper first, rather than directly onto your hardboard or canvas. You will probably find that quite a bit of experimenting and juggling will be required to get each of these fragmented studies to unify into a composition, and you will need to do several small roughs; and when you feel you have arrived at the most satisfactory arrange-ment you can then transfer this sketch to the canvas by squaring up.

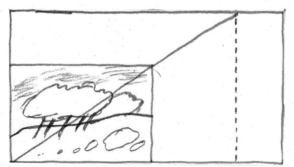

Fig 74

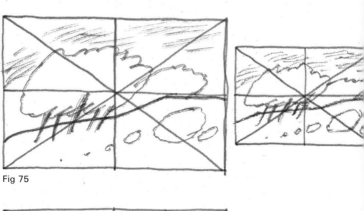

Fig 75

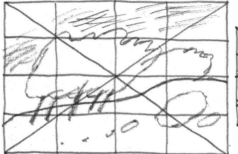

Fig 76

Squaring up and transposing a composition

1 (Fig. 74) Lay your sketch, trimmed to the proportions that you want the finished picture to have, on the left-hand corner of your prepared canvas or hardboard, with the bottom and left-hand edges of the sketch flush to the corresponding corners of the canvas.

2 Draw a diagonal line from the bottom left-hand corner of your sketch to its top right-hand corner and continue until it cuts across the top or right-hand edge of the canvas. This point will be the right-hand top corner of your finished picture, so draw a straight line, either vertical or horizontal as the case may be, from this point across the canvas, in order to define the finished area in strict proportion to the sketch.

3 (Fig. 75) To square up, take the sketch off the board and divide it as shown. Make the same divisions on the picture area marked off on your canvas.

4 (Fig. 76) Now break down these divisions further, first on the sketch and then, exactly the same, on the board.

5 With your picture fragmented like a jigsaw puzzle, you can now copy each piece of the original into the corresponding area on the canvas or hardboard.

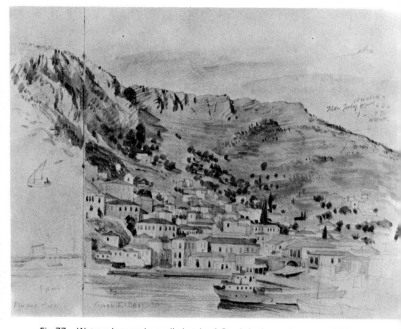

Fig 77 Watercolour and pencil sketch of Greek harbour, done on a thick water-colour paper in large sketch-book, 13½in.×9in. (34cm.×23cm.)

Reference sketches

How you build up your reference sketches depends a lot on your personal taste. I like to keep my large and small sketch-books in two uniform sizes and then I simply stick a tab on the spine or cover saying roughly what they contain and the dates I started and completed them. I find it simplest to keep one large and one

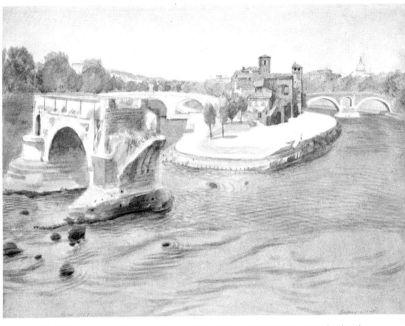

Fig 78 Watercolour painting of Ponte Rotto, Rome, done from the study sketch shown in fig. 40. 18in.×24in. (46cm.×61cm.)

small sketch-book going at a time, but you may prefer to keep individual sketch-books for each subject, say one for landscapes, one for people, etc. Loose sketches and studies are best kept in a large folder which prevents them from getting untidy or damaged.

water for donkey
with foal.

Fig 79 Donkeys in Greece. 11in. × 18in. (28cm. × 46cm.)

Well at Hydra . 21ᵗʰ July 62 .

P.gati.

10 · 30 a.m.

white

pale

Stella Tsamus.

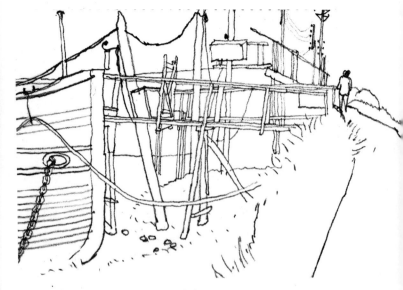

Fig 80 Towpath and boats. 6in.×9¼in. (15cm.×24cm.)

Framing

If you have done a sketch simply as an end in itself and you feel it is successful and has the special qualities that you were trying to capture when you did it, or if it is such an attractive thing on its own that, rather than use it just for reference, you want to keep it as something special, it is a good idea to have it framed and then it will give you constant enjoyment.

Unless you have special equipment such as a mount-cutting knife and an angled framing saw, it is wisest to go to a specialist, as framing is a skilled and professional job.

Your picture will almost definitely look better in a mount (mat) and frame rather than in a frame on its own. Choose a card (mat-board) from the selection that the framer will show you, either a

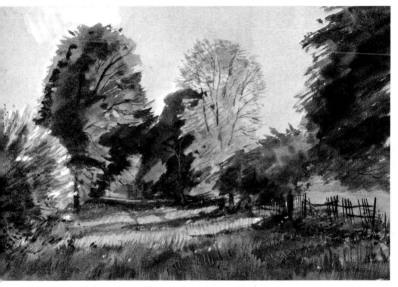

Fig 81 Trees. Watercolour, 13¼in.×20½in. (34cm.×52cm.)

white or tone card whichever you feel complements or intensifies your picture. The width of the card (matboard) is something that depends on many things; a small intense study could take a deep mount (mat), a large broad study a relatively narrow one.

The frame is also a matter of personal taste, but I prefer simple ones, either pale wood, white, or thin plain silver or gold, as these do not attract attention away from the picture but give it a nice finish. Ornamental frames, besides being more expensive, can be difficult to hang in certain surroundings and may 'date' a bit in time. It is after all the picture itself you want to be aware of, the mounting and framing is simply a finish to it and a good way of protecting it and hanging it on the wall.

Conclusion

Fig 82 Square buildings, Gozo. 4¾in.×9in. (12cm.×23cm.)

Once you have started sketching you will want to continue with it, for you will find that the more you do the better you get at describing in your sketch-book what you see. You will find that everything you look at now has greater meaning, for you will not see things simply as objects of usual association that you have almost ceased to notice, but as shapes and form and colour that are stimulating and fascinating. Bits of pattern and texture, things such as a pile of pebbles, or derelict buildings, you will now stop and look at closely, and really see for the first time. To build up a habit of 'looking' as the artist has to, is to see things freshly as a child does and to have constant visual pleasure.

If you enjoy group activities, the stimulus of discussion and the exchange of ideas with others, there are in most areas sketching or art clubs, consisting of groups of people like yourself—not usually professional artists but those who have started sketching,

drawing and painting and found an enjoyment that they like to share. These groups generally meet frequently and informally, and sometimes go out sketching together, and it is a good way of making friends with people of similar interests.

You can also go on sketching holidays, either forming a group to travel somewhere that you might not normally visit or going out to an art centre for a week-end or longer on a course where you will receive expert tuition. Particulars of these centres can be found in most art magazines such as *Arts Review* or *Canvas* etc. (In the U.S. this information can be found in the Art School Directory, published annually by American Artist, or in the Schools section of the American Art Directory.) So besides broadening your own experience, sketching can provide a new interest and bond with your family or friends and give you enjoyment for the rest of your life.

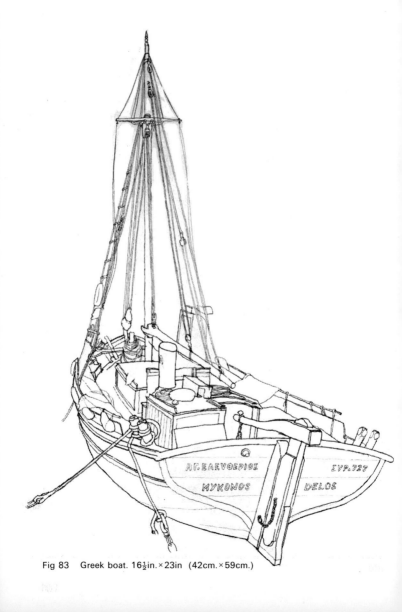

Fig 83 Greek boat. 16½in. × 23in (42cm. × 59cm.)

For further reading

Creative Pencil Drawing by Paul Hogarth; Studio Vista, London and Watson-Guptill, New York, 1964

Drawing Lessons from the Great Masters by Robert Beverly Hale; Studio Vista, London and Watson-Guptill, New York, 1965

Egon Schiele by Rudolph Leopold; Pall Mall Press, London, 1971

Henry Moore: Sculpture and Drawings 1921–1948 (Vol. 1) ed. by David Sylvester; Lund Humphries, London, 1957 and Praeger, New York, 1968

Samuel Palmer, the Visionary Years by Geoffrey Grigson; Routledge, London, 1947, and Boston Book and Art Shop, Inc., Boston

The Life and Work of Albrecht Dürer by Marcel Brion; Thames and Hudson, London, 1965

Augustus John. Drawings by Lillian Browse, with 'A Note on Drawing' by Augustus John; Faber, London, 1941

Matthew Smith by John Rothenstein; Oldbourne Press, London and Dufour Editions, Inc., Chester Springs, Pennsylvania, 1962

J. M. W. Turner: His Life and Work by Jack Lindsay; Cory Adams and Mackay, London and New York Graphic, Greenwich, Connecticut, 1966

Memoirs of the Life of John Constable ed. by C. R. Leslie; Phaidon, London, 1961, and Praeger, New York, 1951

Leonardo Da Vinci on Painting by Carlo Pedretti; Peter Owen, London, 1968

Stanley Spencer by Elizabeth Rothenstein; Oldbourne Press, London and Dufour Editions, Inc., Chester Springs, Pennsylvania, 1962

A Free House, the writings of Walter Richard Sickert, ed. by Osbert Sitwell; Macmillan, London, 1947

Ben Nicholson: Drawings, Paintings and Reliefs, 1911–1968 int. by John Russell; Thames and Hudson, London and Harry N. Abrams, New York, 1969

Picture Framing for Beginners by Prudence Nuttall; Studio Vista, London and Watson-Guptill, New York, 1968

Index